DRAW Doodle Style!

You can, of course, add as much, or as little, to a doodle as you want.

Cosmos Flower

An over-doodled Doodle......

By jen tennille

Draw Doodle Style: The Cosmos Flower

Copyright Jen Tennille
2013
All Rights Reserved.
www.jentennille.com
Vancouver, WA
U.S.A.

This booklet was primarily written and drawn by hand. Remember when we used to do things with pens and pencils before computer programs and emails took over? I do. I chose to keep this tutorial as handmade as possible and hope you enjoy the format!

Draw Doodle Style!

By
Jen Tennille

Table of Contents

The Cosmos Flower ... 6

The Center and Petals ... 11

The Petal Spirals... 13

The Leaves ..15

The Stem.. 19

Draw Doodle Style: The Cosmos Flower

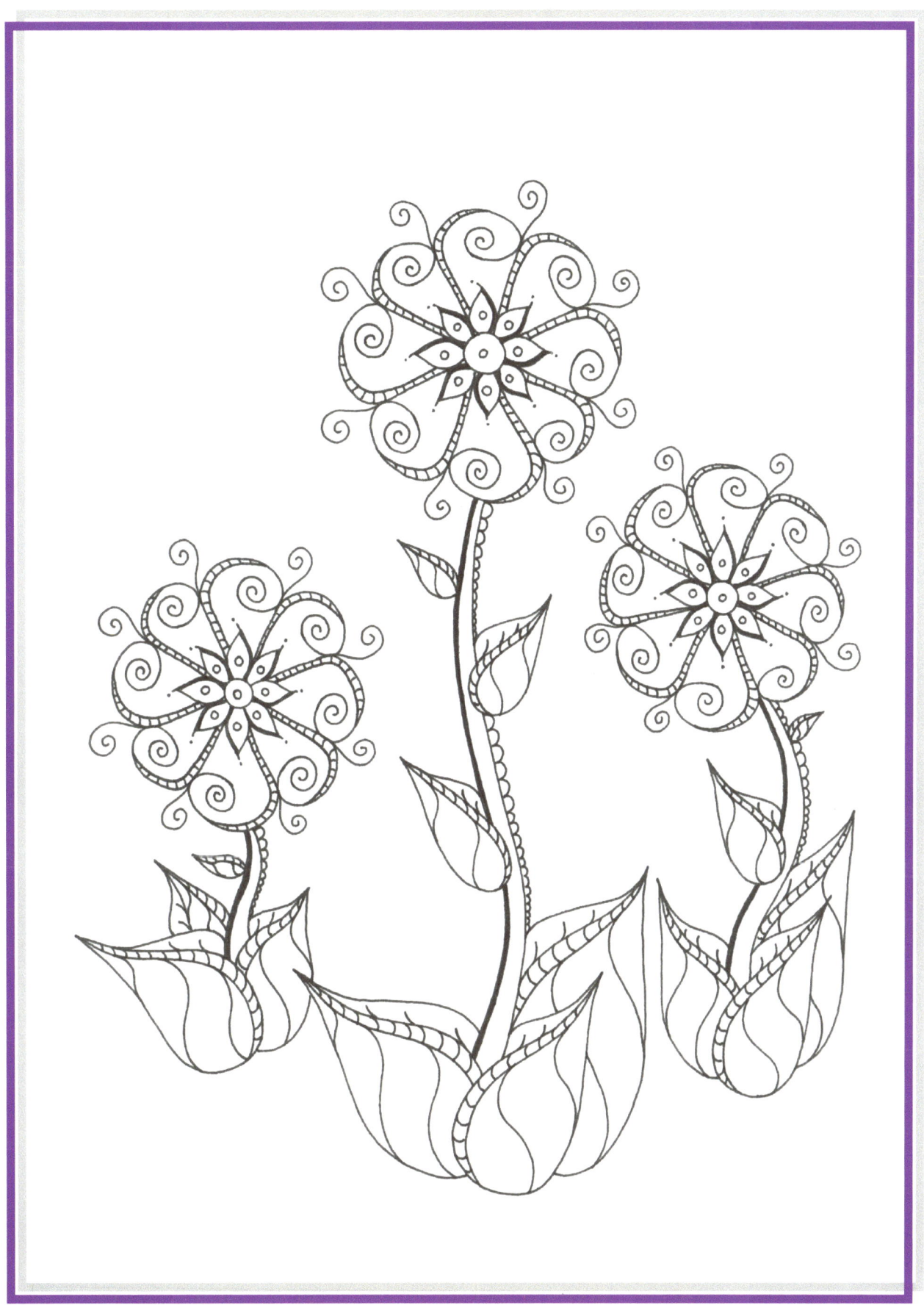

The Cosmos Flower

Draw Doodle Style: The Cosmos Flower

Cosmos Flower (Don't draw the dotted lines)

#1.

Draw a circle for the center.

#2.

Draw the top and bottom first two petals. They don't have to be the same length or width. Just make sure the tips are straight (like the dotted line.)

#3

#4

* Don't be afraid to turn (rotate) the page when you draw each petal!

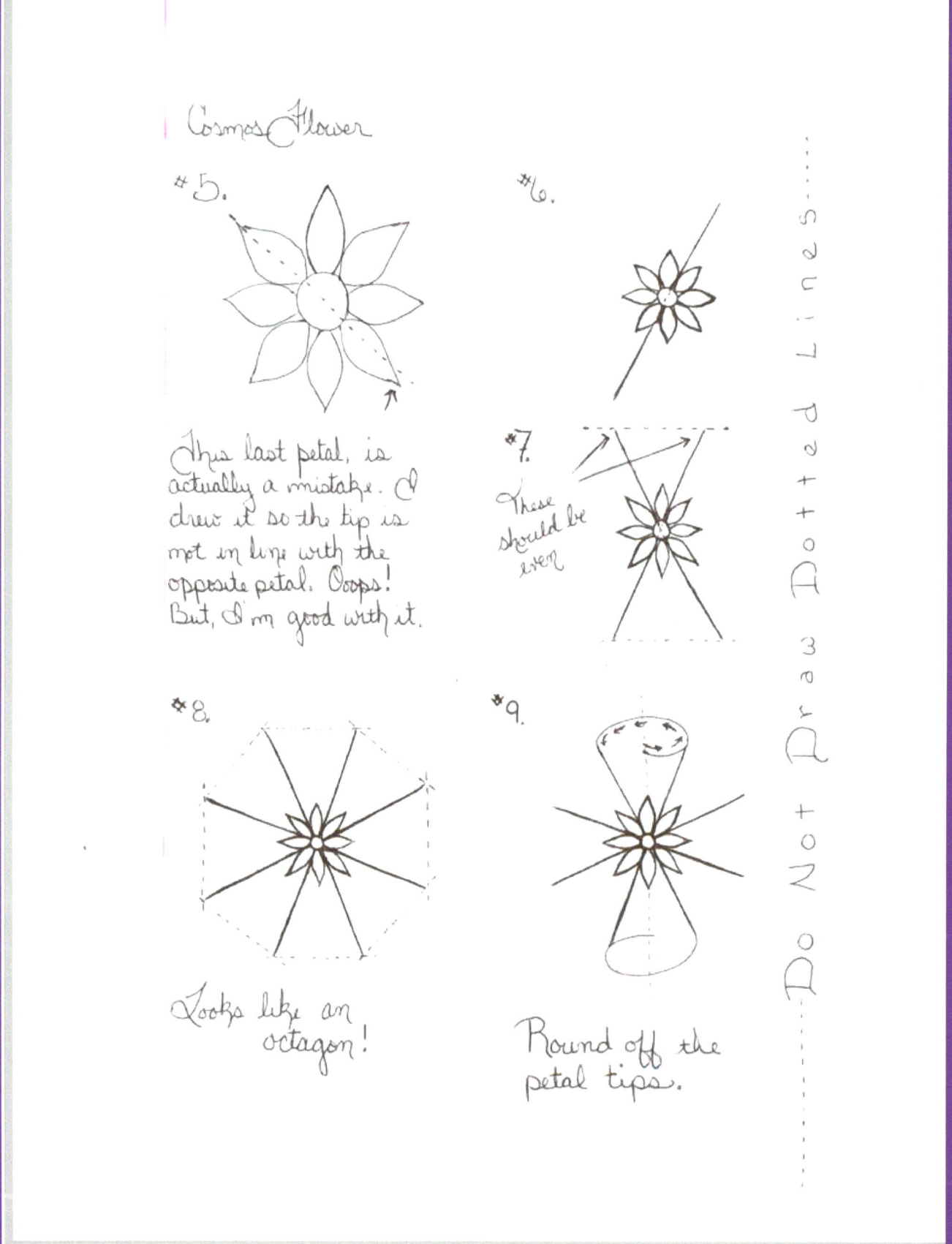

Draw Doodle Style: The Cosmos Flower

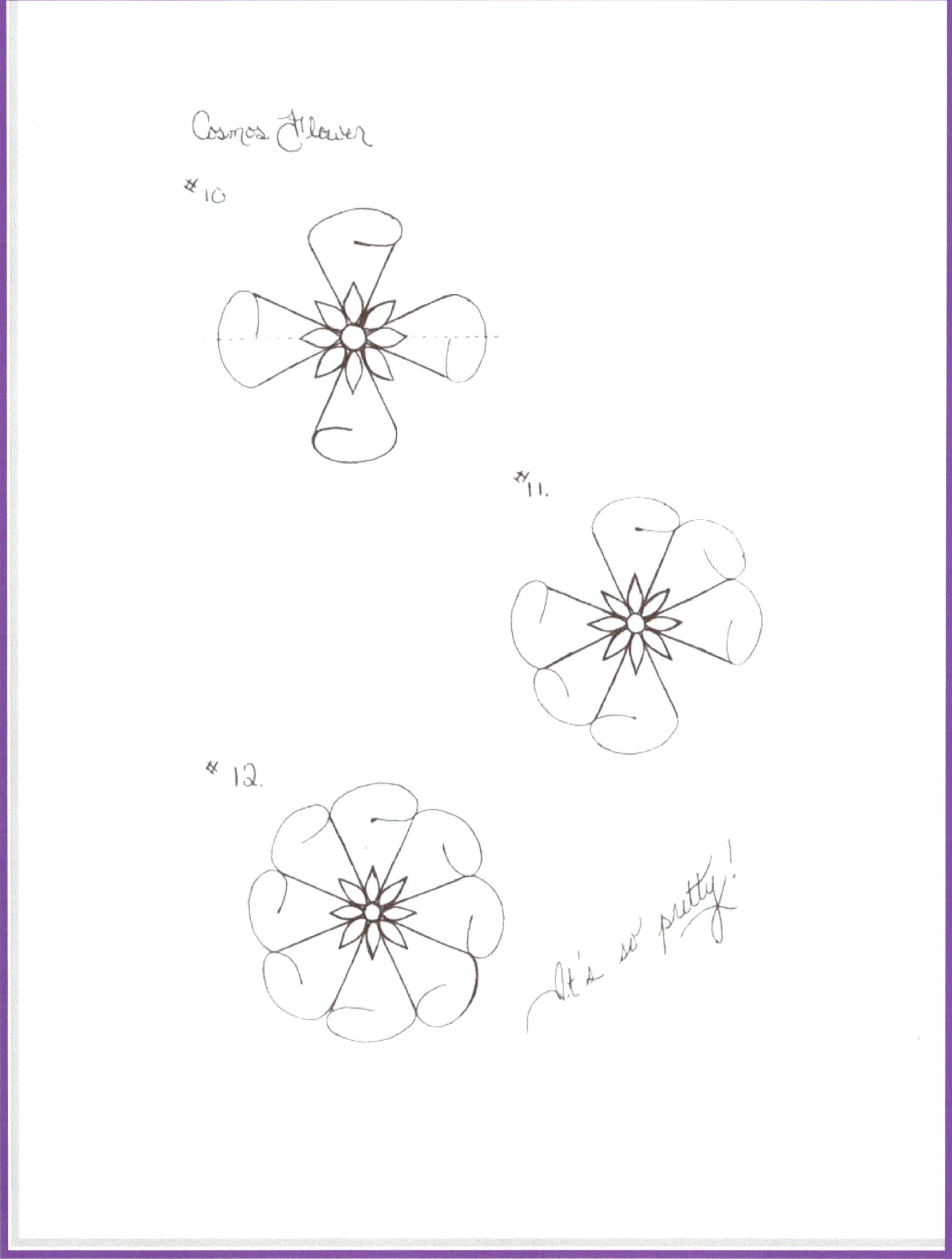

9

Draw Doodle Style: The Cosmos Flower

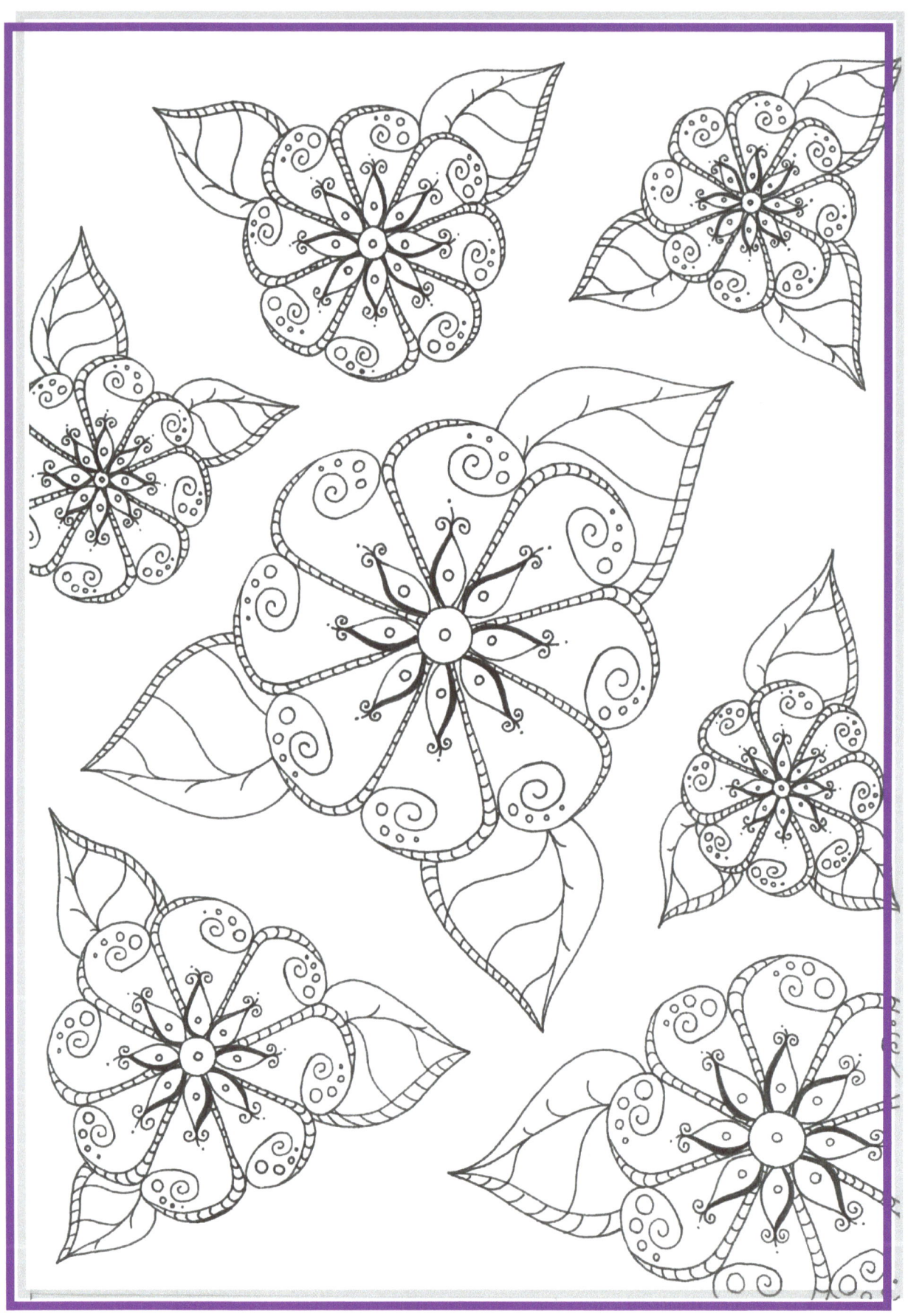

The Center and Petals

Cosmos Flower Doodle Breakdown

The Flower's Center:

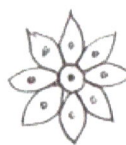 Add a dot to the center circle and in the middle of each petal.

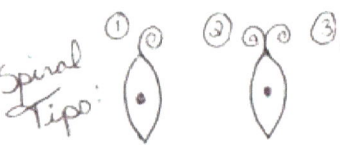 Spiral Tips: Darken the right side (or left) of each petal: (whichever you feel like.)

The Flower's Petals

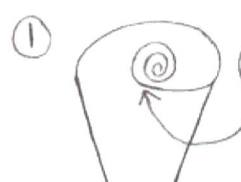 Extend this line into a spiral

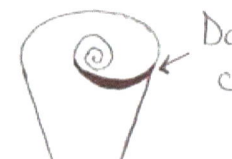 Darken the curve

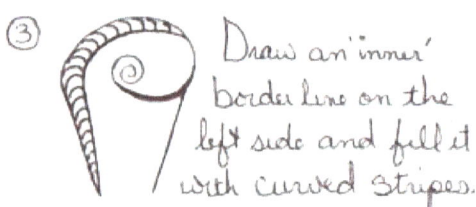 Draw an 'inner' border line on the left side and fill it with curved stripes.

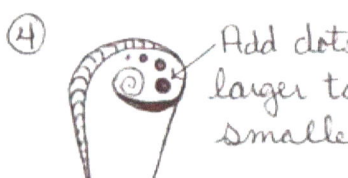 Add dots - larger to smaller

⑤ Thicken and Darken the outer boarder line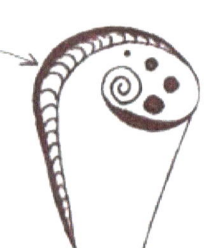

The Petal Spirals

Cosmos Flower Doodle Breakdown

The Petal Spirals:

#1 Start with a basic spiral.

#2 Add scallops that go from small to large and back to small.

#3 Draw lashes out from inbetween the medium to large scallops and dot them like an "i".

#4 If you wish, you can darken the line of the basic spiral to make it stand out more.

The Leaves

Draw Doodle Style: The Cosmos Flower

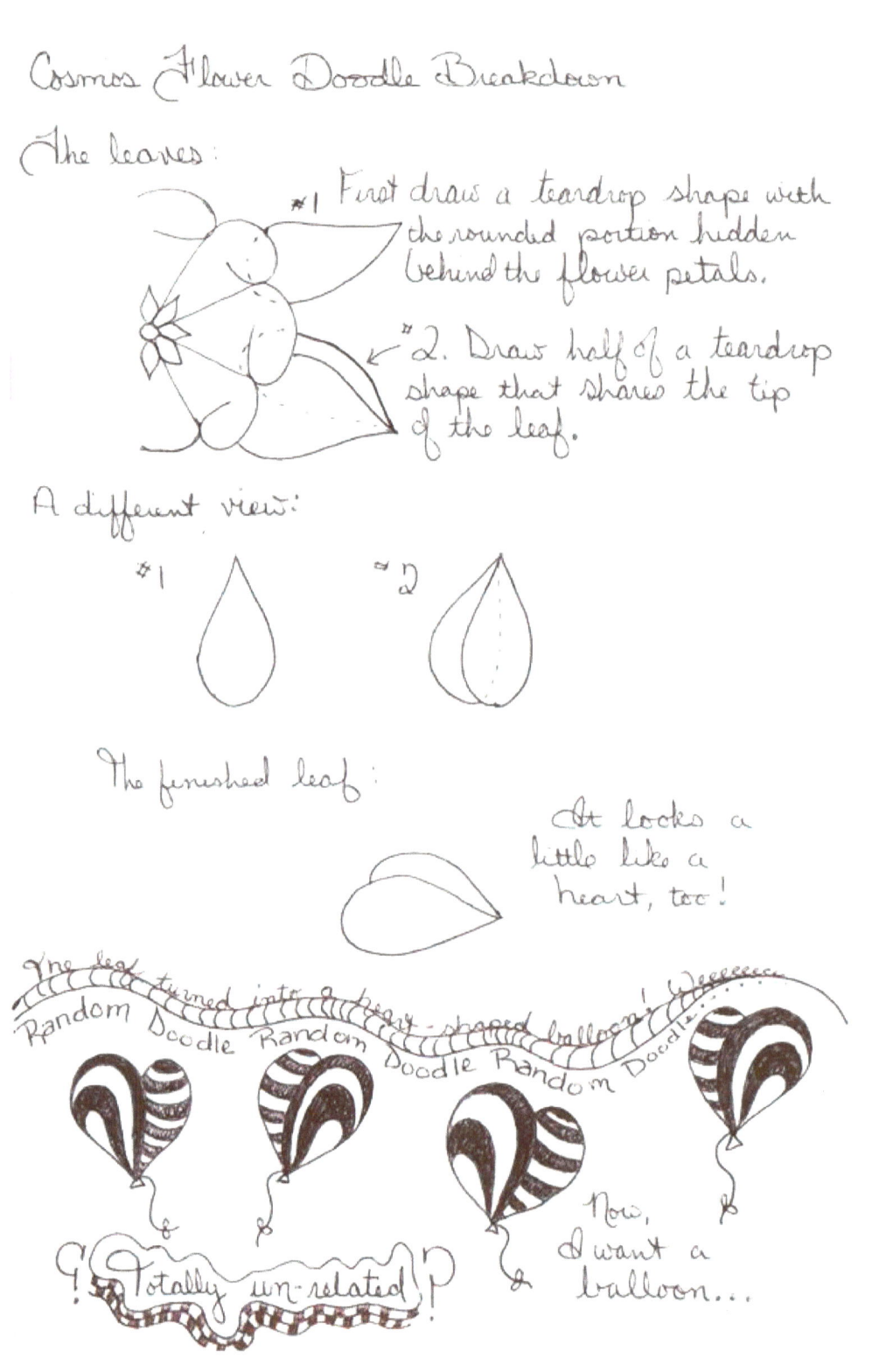

Draw Doodle Style: The Cosmos Flower

Cosmos Flower Doodle Breakdown

To Doodle the leaf:

#1 — Draw 2-3 curvy veins on the big side of the leaf that go all the way to the edge.

#2 — Draw 2-3 lash-like veins that go about to the middle of the thinner half of the leaf.

#3 — Draw a border line on the inside of the large half of the leaf.

#4 — Stripe the border following the curved lines of the veins.

#5 — Add Dots

Cosmos Flower Doodle Breakdown

To Doodle the leaf (continued)...

#6. Spirals & Dotted Lash on the tip of the leaf

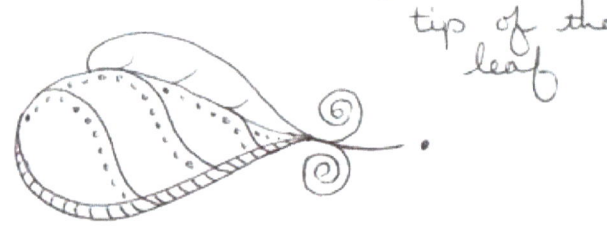

a. b. c.

#7. Darken the outer line of the thin side of the leaf and the inner line of the stripped border.

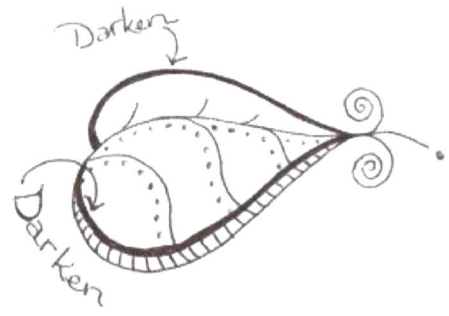

The Stem

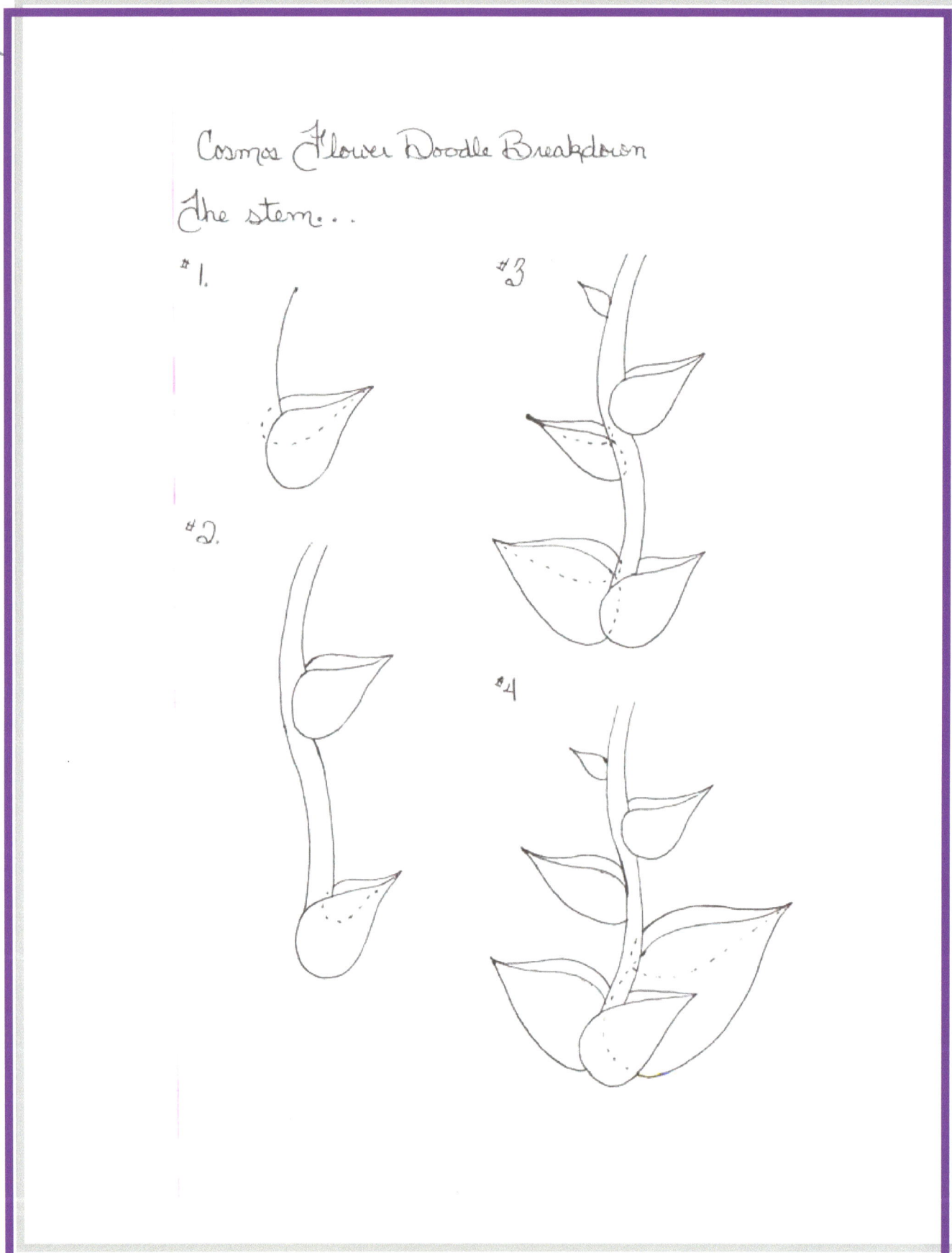

Draw Doodle Style: The Cosmos Flower

Cosmos Flower Doodle Breakdown

The stem...

All of the leaves are embellished the same except for two:

These two leaves are folded and "cup" the stem.

Here is how I delt with them:

#1. the veins are opposite

vs.

#2. Border on the inside.

#3. Dots.

#4. Spiral tip.

#5 Darken in lines.

Darken ↓ Darken Darken

Draw Doodle Style: The Cosmos Flower

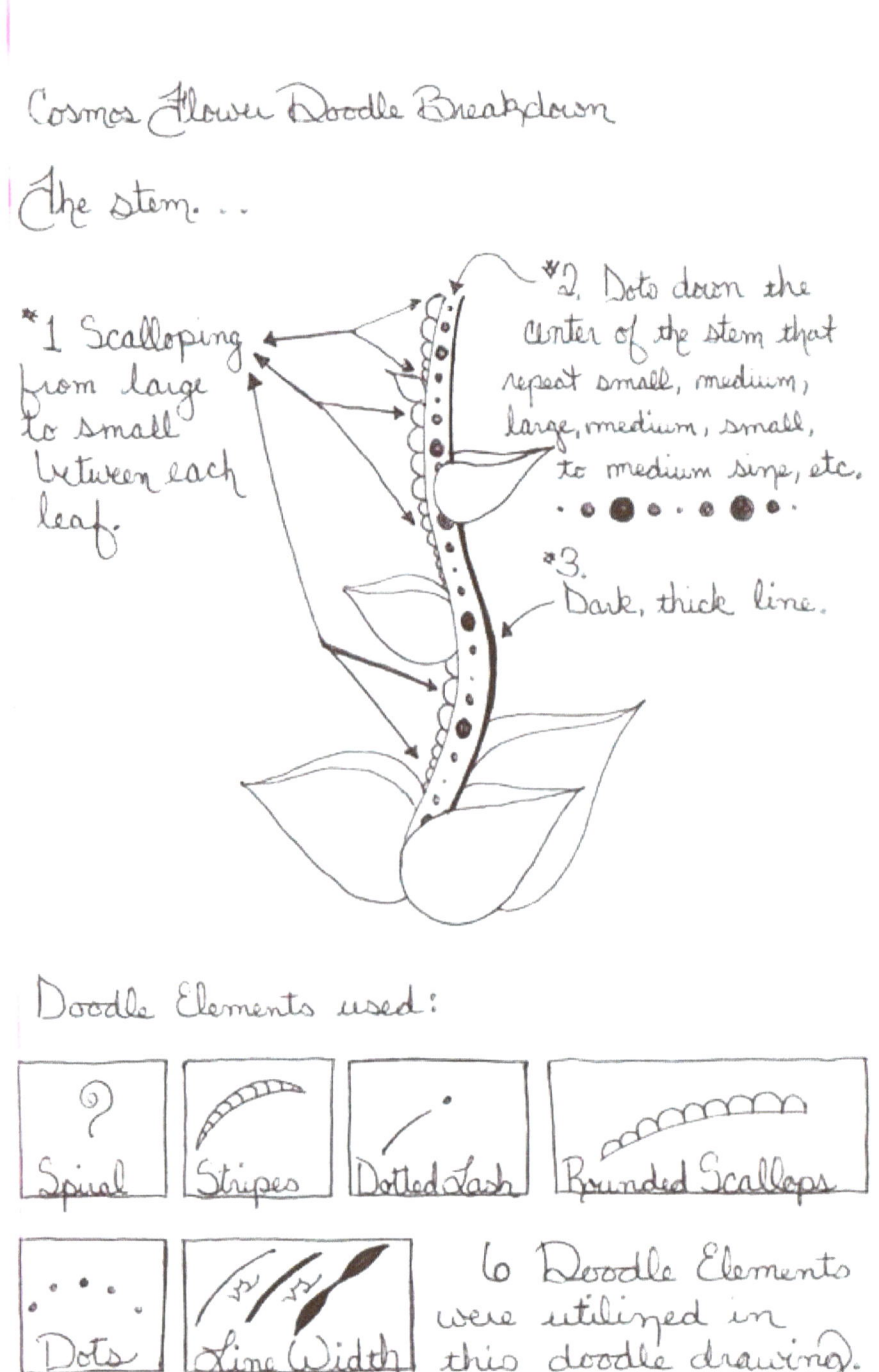

Cosmos Flower Doodle Breakdown

The stem...

*1 Scalloping from large to small between each leaf.

*2. Dots down the center of the stem that repeat small, medium, large, medium, small, to medium size, etc.

*3. Dark, thick line.

Doodle Elements used:

| Spiral | Stripes | Dotted Lash | Rounded Scallops |

| Dots | Line Width |

6 Doodle Elements were utilized in this doodle drawing.

Draw Doodle Style: The Cosmos Flower

About Jen Tennille

I love to draw! When I picked up my first crayon as a child, I decided never to put it down. I draw in the car (not while driving, though). I draw while watching television (documentaries rock!). I draw late at night to put myself to sleep. I draw in the mornings with my first cup of coffee to wake myself up. I draw while I listen to audio books or a brilliant classical music piece. Drawing is my meditation, my passion, my life
I remember my grandmother filled the back hallway of our home with all of her favorite drawings. Every time we had someone over, she had to show them the newest addition to her personal gallery! While my drawings have evolved and improved over the years, one thing remains the same-my love for drawing. Doodle drawing is not just a hobby, but a passion. I have scribbled on napkins, doodled in the margins of notebooks, created hundreds of complete works, studied, read, studied, and above all, never stopped drawing. It is this love and inner joy for doodle art that I wish to share with everyone I can. I have learned so many things...the hard way, I might add...and am committed to sharing my knowledge and skills so others can share the happiness that drawing and doodling brings with less of the frustration of trying to find tutorials that aren't focused on the fine art aspect of drawing. Believe it or not, there are many others out there who just want to draw and doodle for fun, not become the next Picasso!
By combining my knowledge of drawing and doodling, graphic design, and computer savvy, I hope to bring ease of access to learning how to draw doodle style and the warm, gushy feeling you get with every finished piece of art!

http://www.jentennille.com
http://www.jentennille.com/blog
https://www.etsy.com/shop/jentennille
http://www.flickr.com/photos/jentennille/
https://www.facebook.com/pages/Jen-Tennille/264504136962511

Draw Doodle Style: The Cosmos Flower

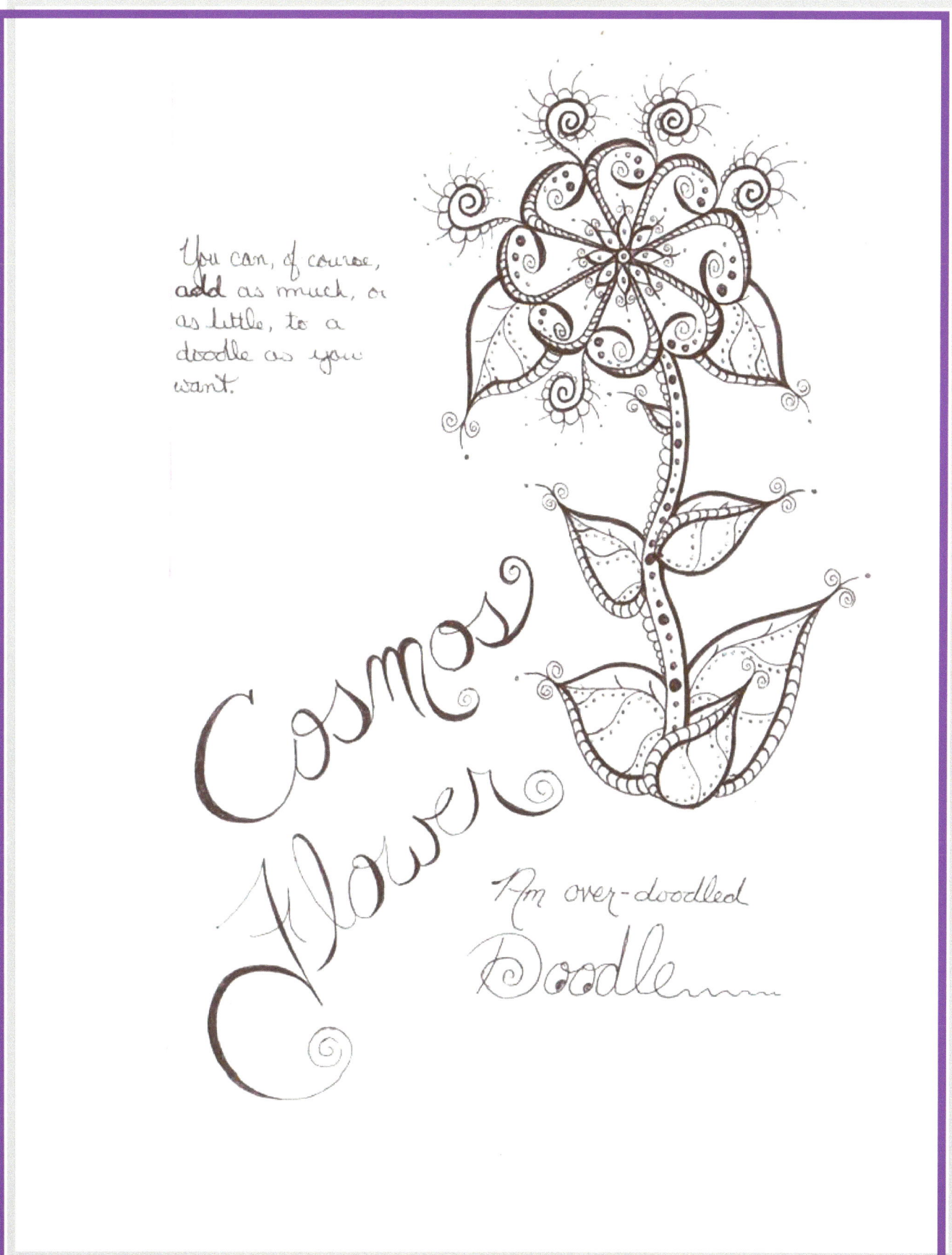

www.ingramcontent.com/pod-product-compliance
Lightning Source LLC
Chambersburg PA
CBHW050435180526
45159CB00006B/2541